How to Draw

Leprechauns

In Simple Steps

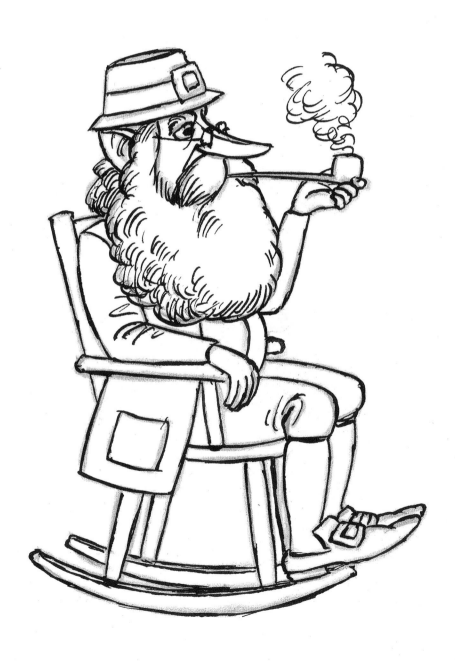

First published in Great Britain 2009

Search Press Limited
Wellwood, North Farm Road,
Tunbridge Wells, Kent TN2 3DR

Text and illustrations copyright © Michael Terry 2009

Design copyright © Search Press Ltd. 2009

ISBN: 978-1-84448-4164

Printed in China

Dedication

To my first pencil.

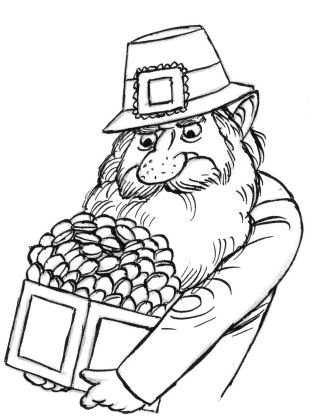

How to Draw
Leprechauns

In Simple Steps
Michael Terry

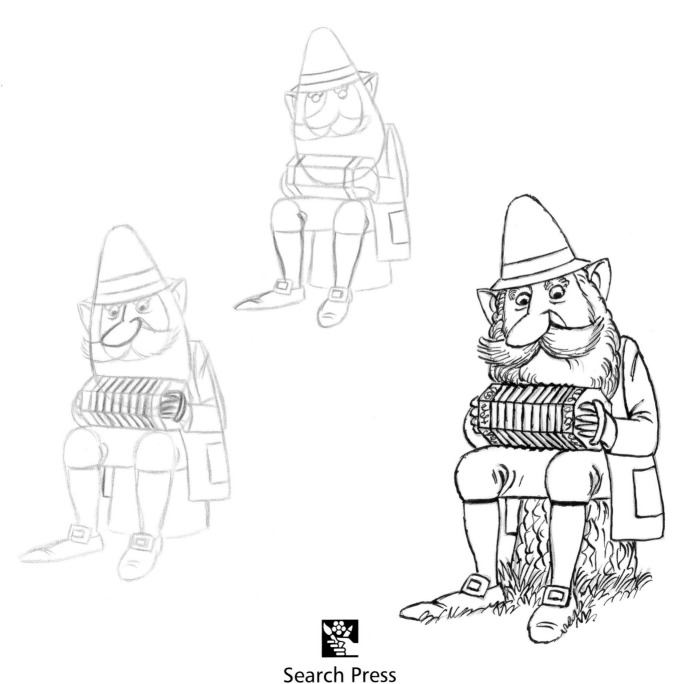

Search Press

Introduction

Leprechauns are mischievous male faerie folk and they are said to live alone in the wild areas of Ireland. They avoid contact with humans, whom they view with suspicion. It is also said that they love drinking poteen, a toxic home brew which causes them to become inebriated, although they are never too intoxicated to forget their shoemaker trade or their role as guardians of fairy treasure. If you are lucky enough to catch sight of a leprechaun, he will invariably be smoking a pipe and wearing a green coat, his grumpy features framed by a wide brimmed hat.

Here, I give you an in-depth approach to achieving a satisfactory finished drawn image of these mythical creatures. In the following pages you will see leprechauns in poses which reflect their character. We are lucky, because they look human, so finding reference for drawings and paintings is easy. If you want to develop your own ideas, ask someone to pose in the position you want, whether it is sitting, standing or moving – then add the clothes and accessories.

When using this book, first choose your leprechaun. You do not have to use the colours I show in this book; I have only included them to explain the various stages. I would suggest that you use a soft pencil like a B or a 2B because this will give you a nice line. Start by sketching in the basic shapes of the figure, so that the overall proportions are correct. Relax and draw the lines loosely and lightly so that any errors or unwanted lines can be erased easily. Compare the shapes to get the proportions right. This is the most important stage of the drawing, because every following step is built upon these initial shapes. Take your time and refine the drawing as you work through the stages, until you are satisfied with the image.

When you feel more confident about your drawing, you may want to introduce colour. I have used a dip pen in the late stages, with intense watercolours added to complete the finished image. The watercolours allow the black lines to show through, and gouache and coloured pencil have been used to finish off.

Try drawing a leprechaun in a landscape, or in any situation you like. Just enjoy yourself and let your imagination go wild. Have fun.

Happy drawing!

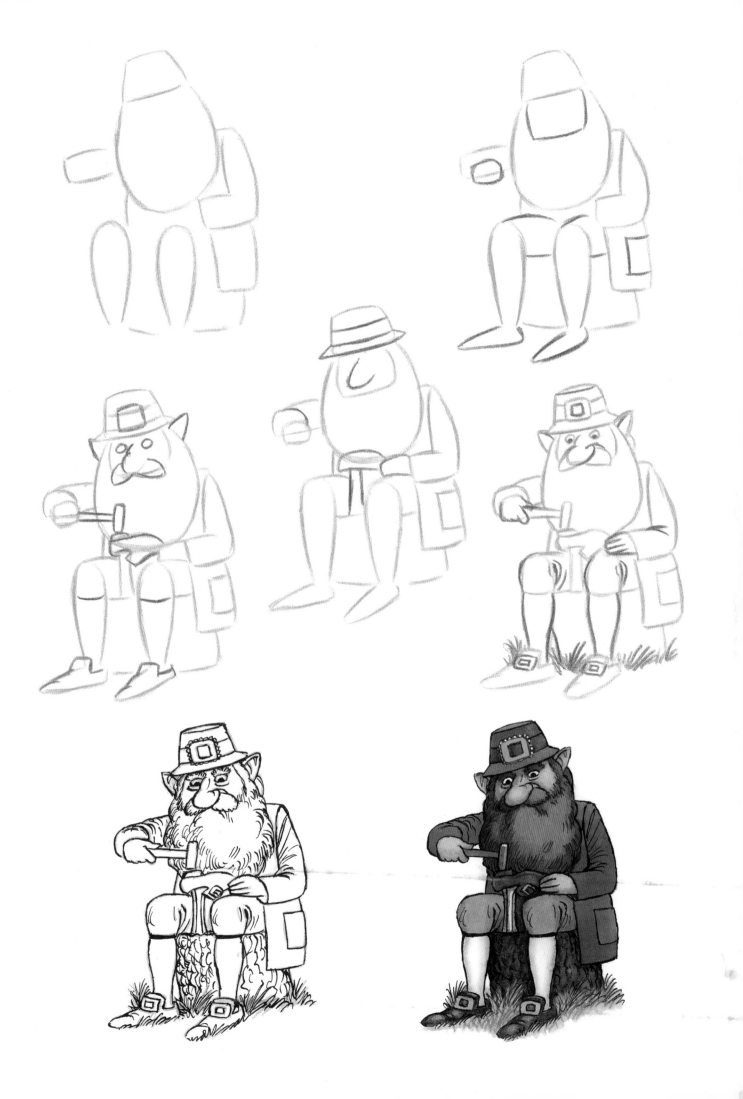

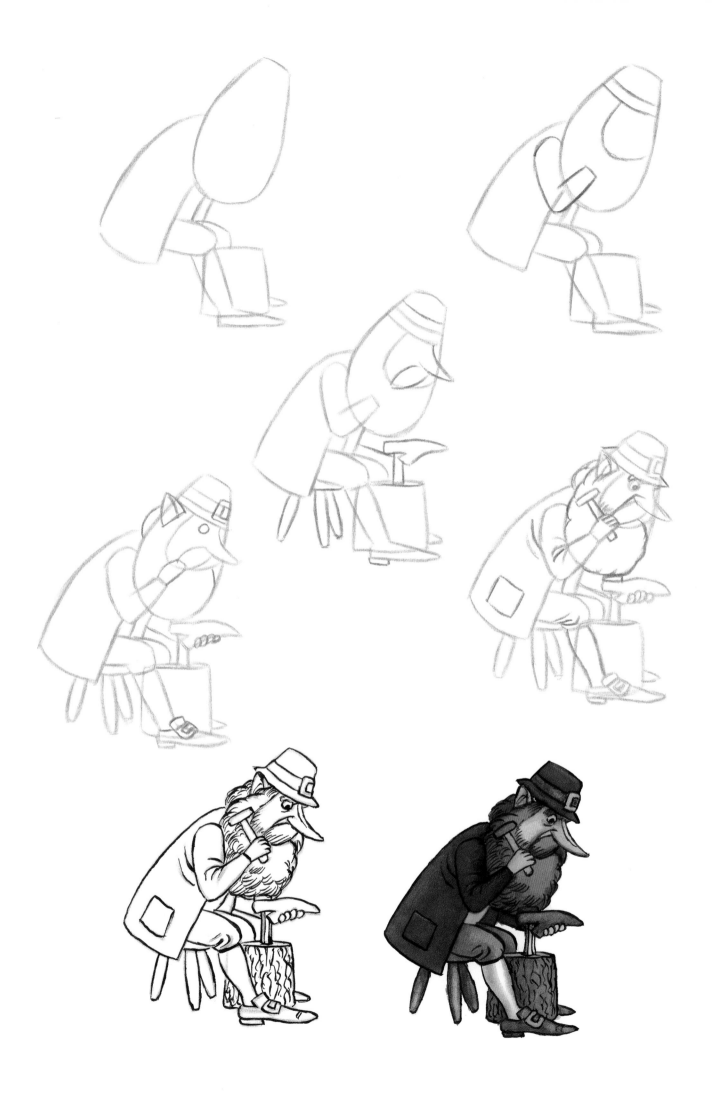

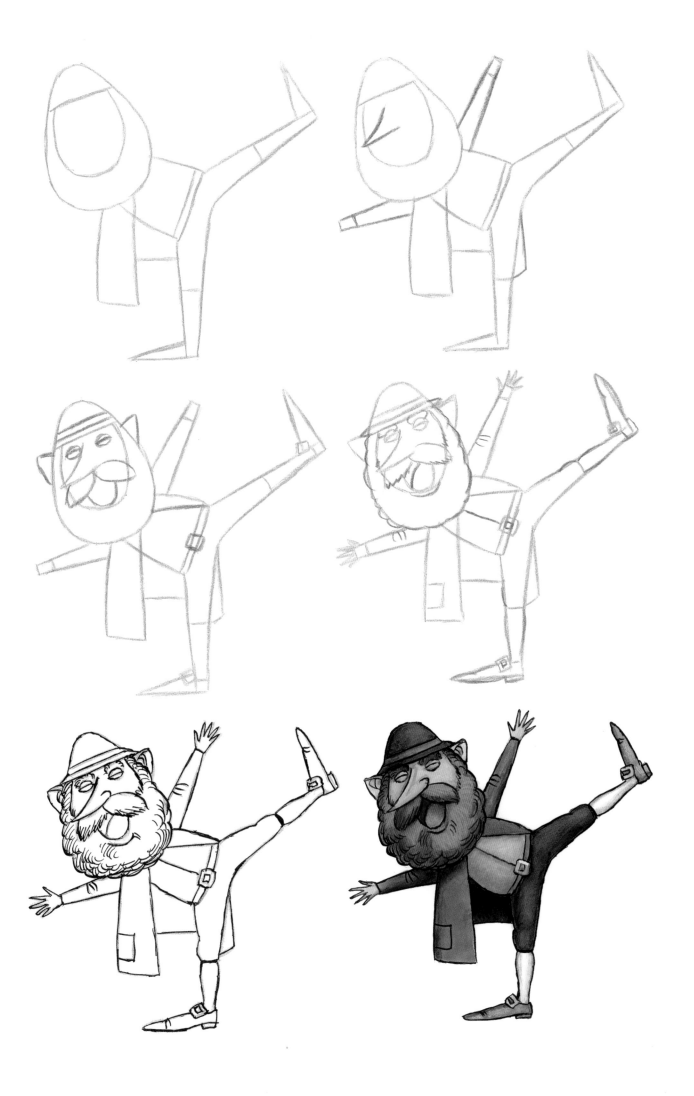

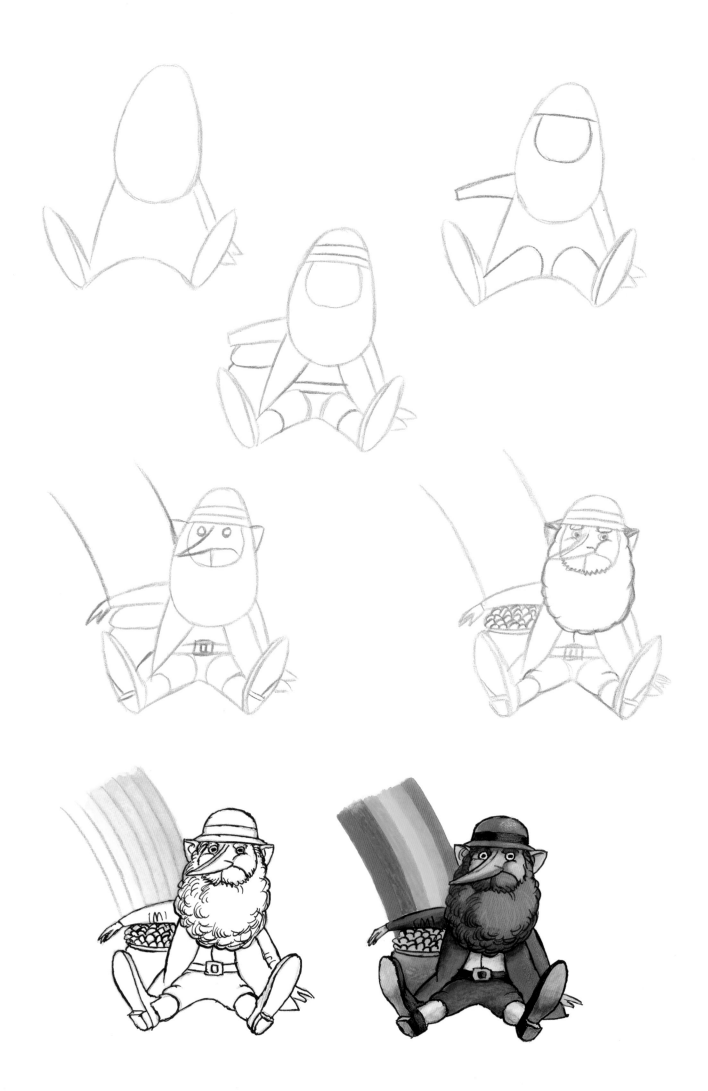

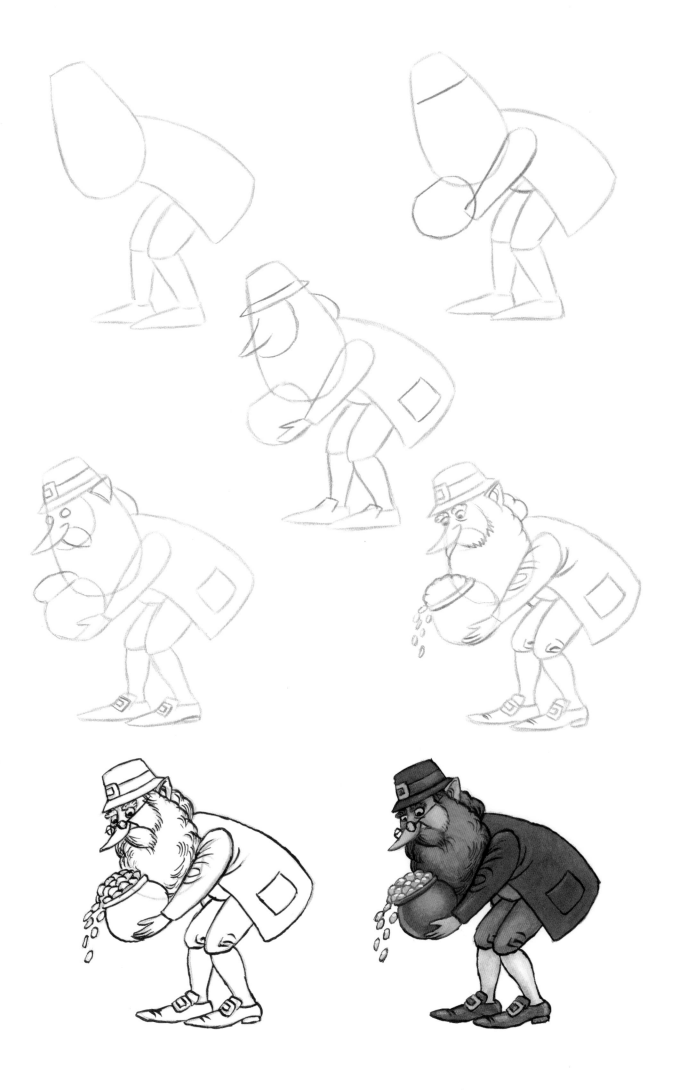

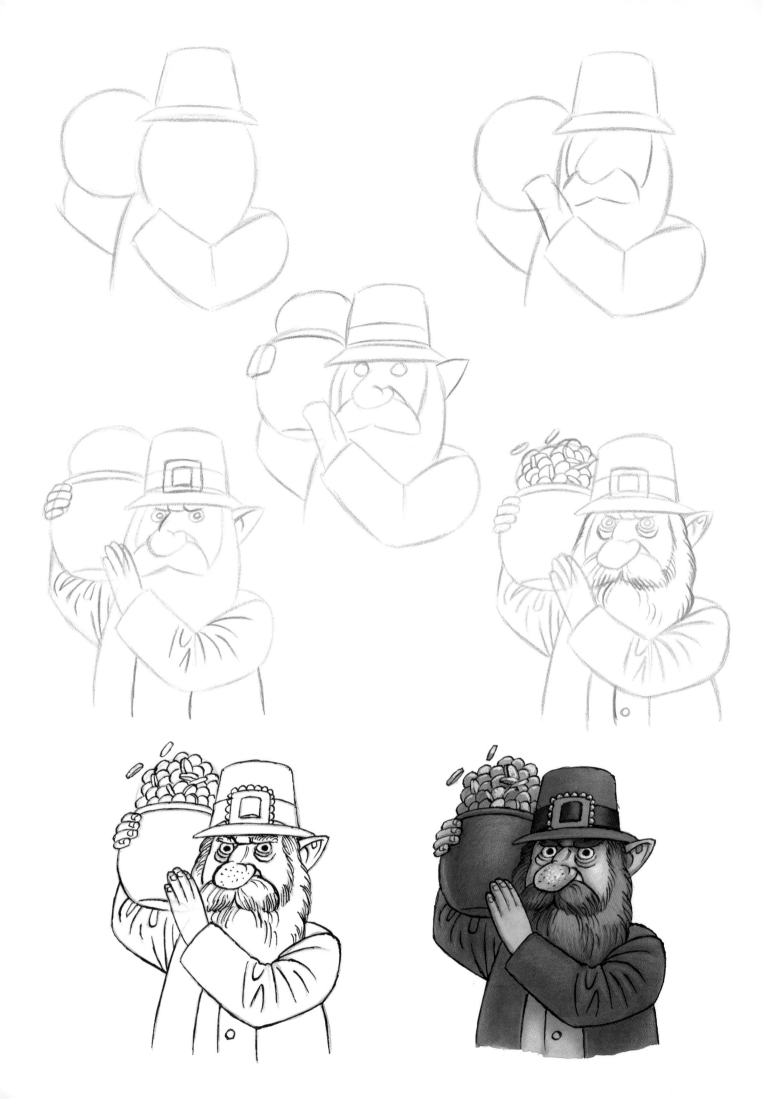

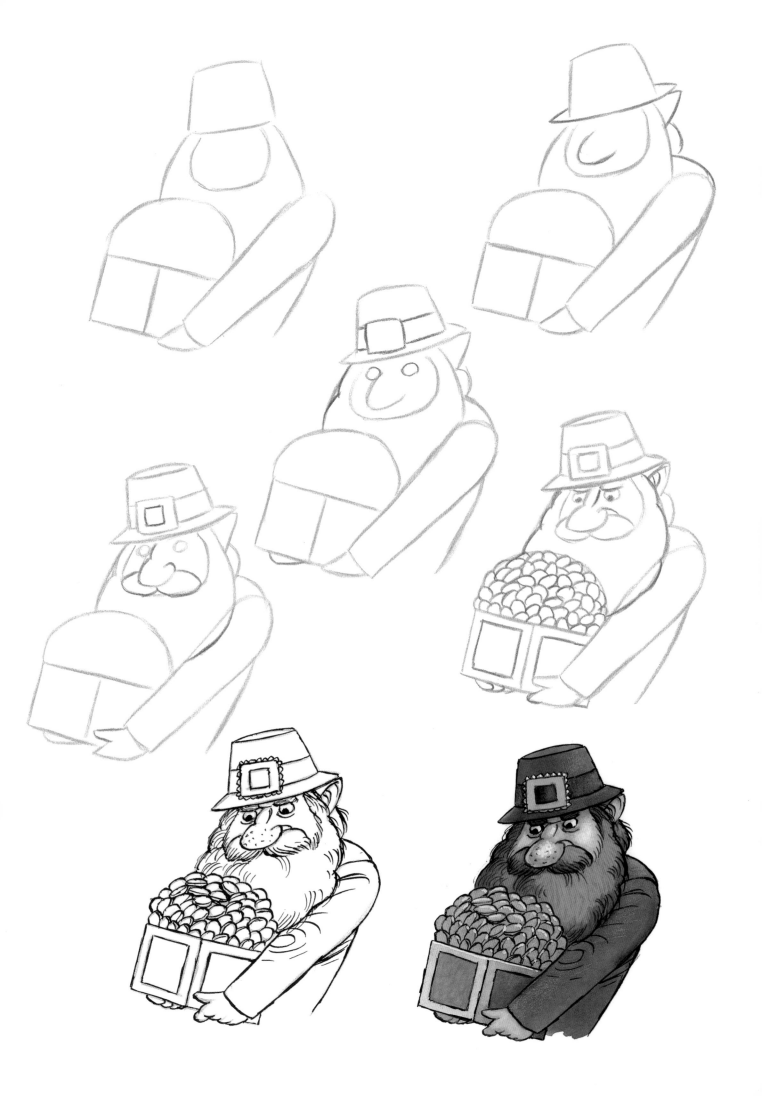

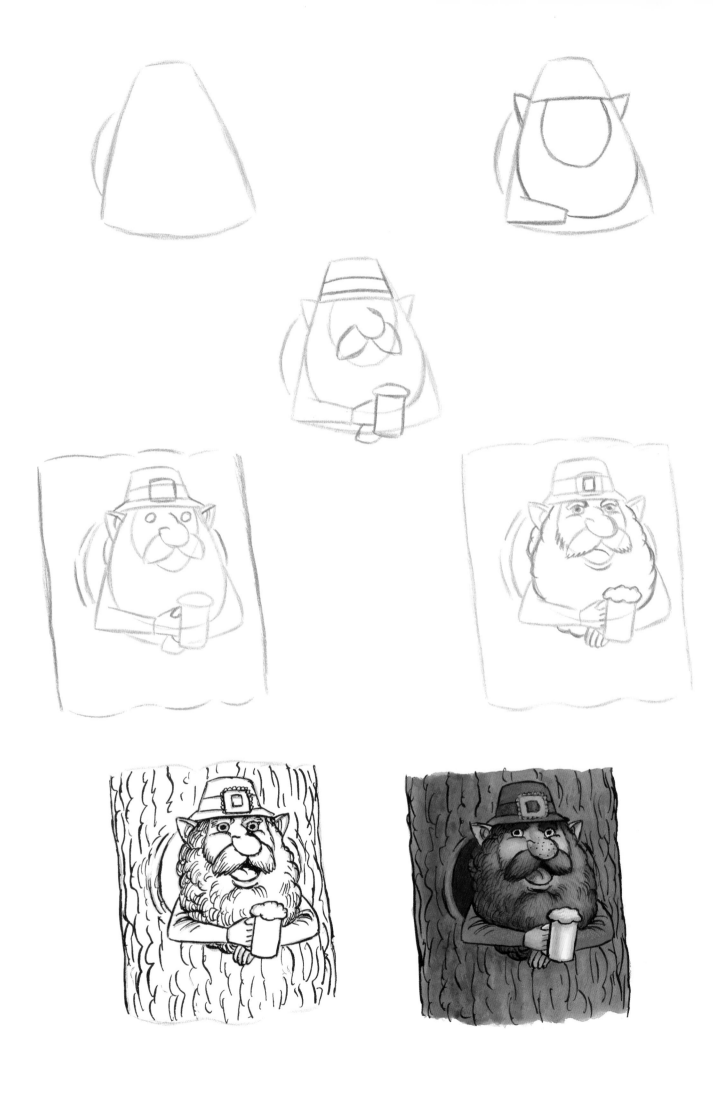

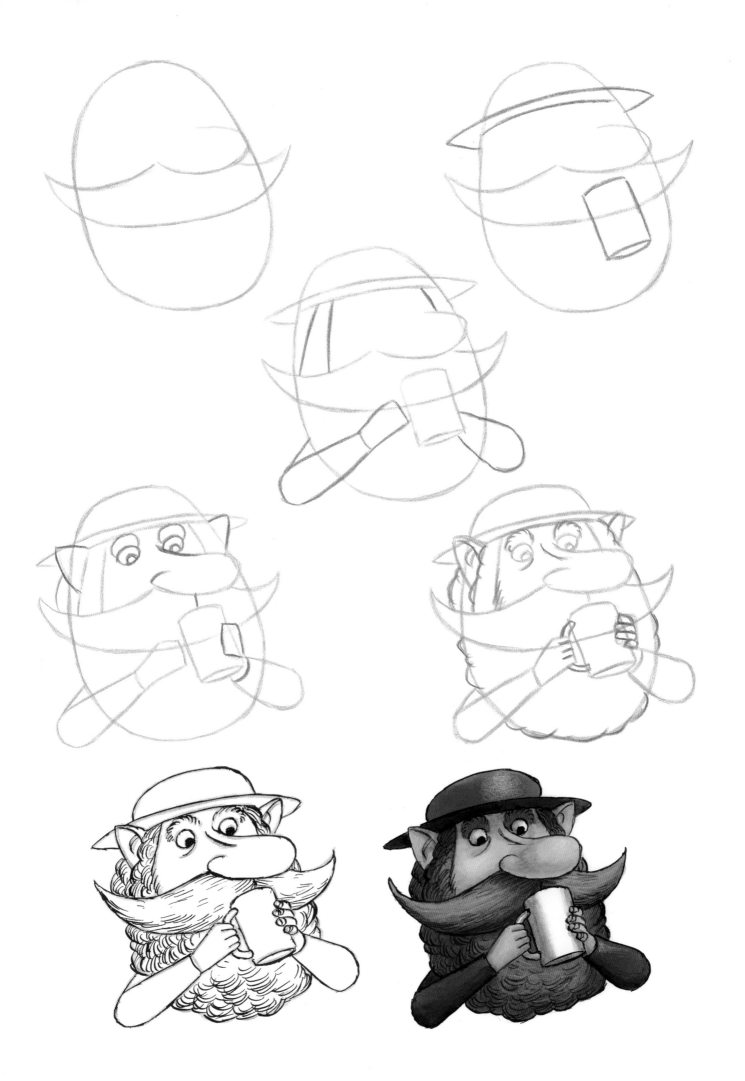

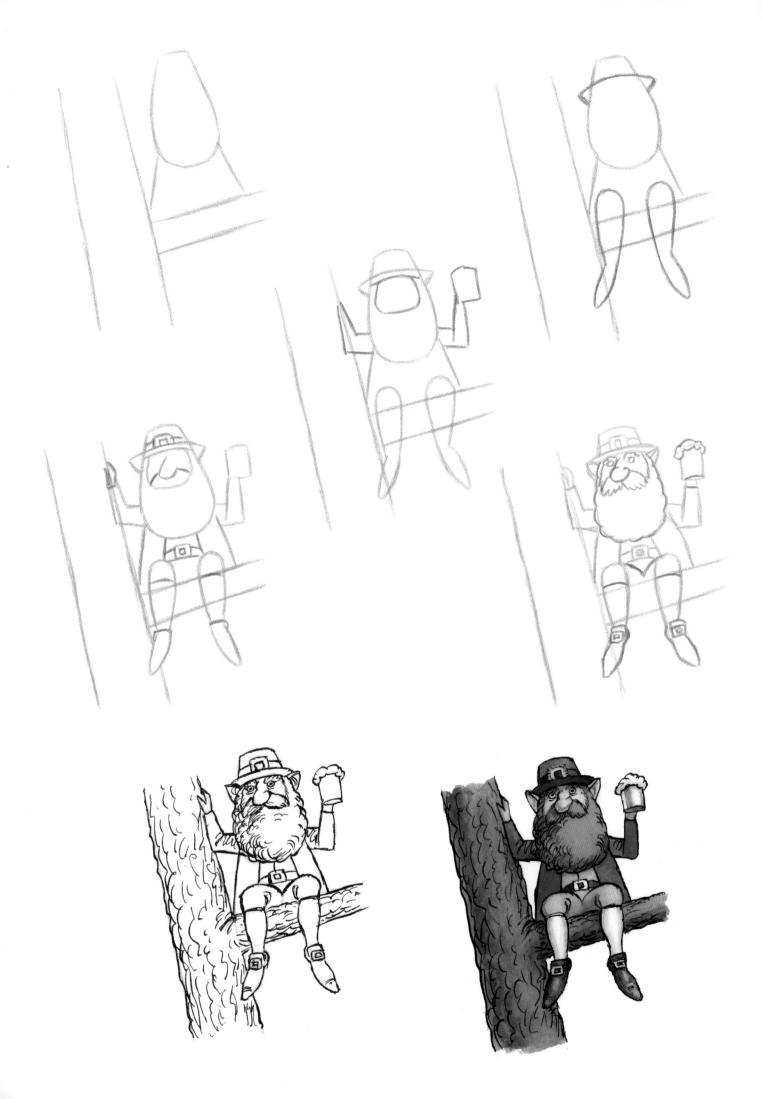

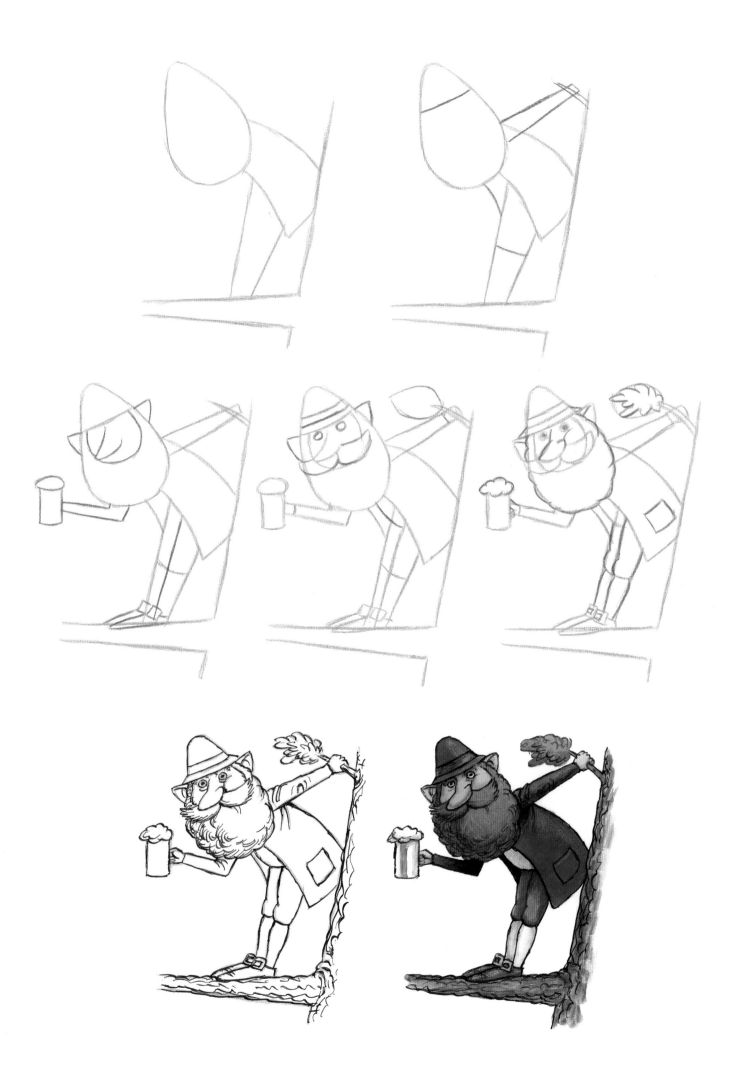

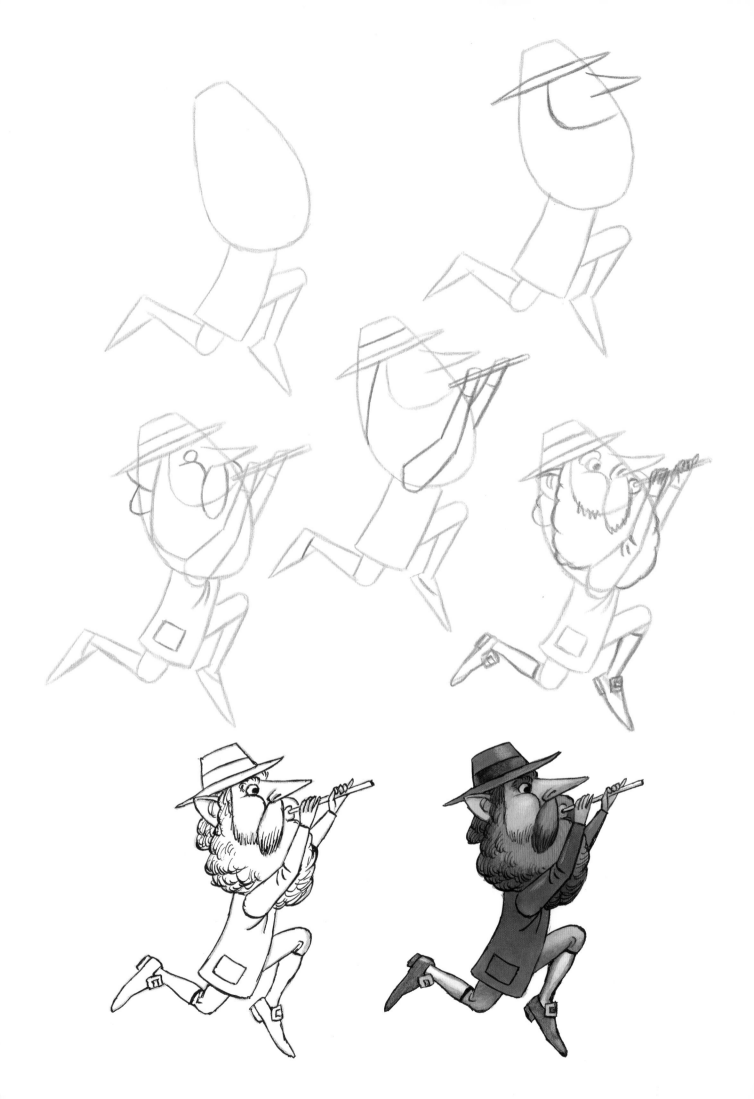

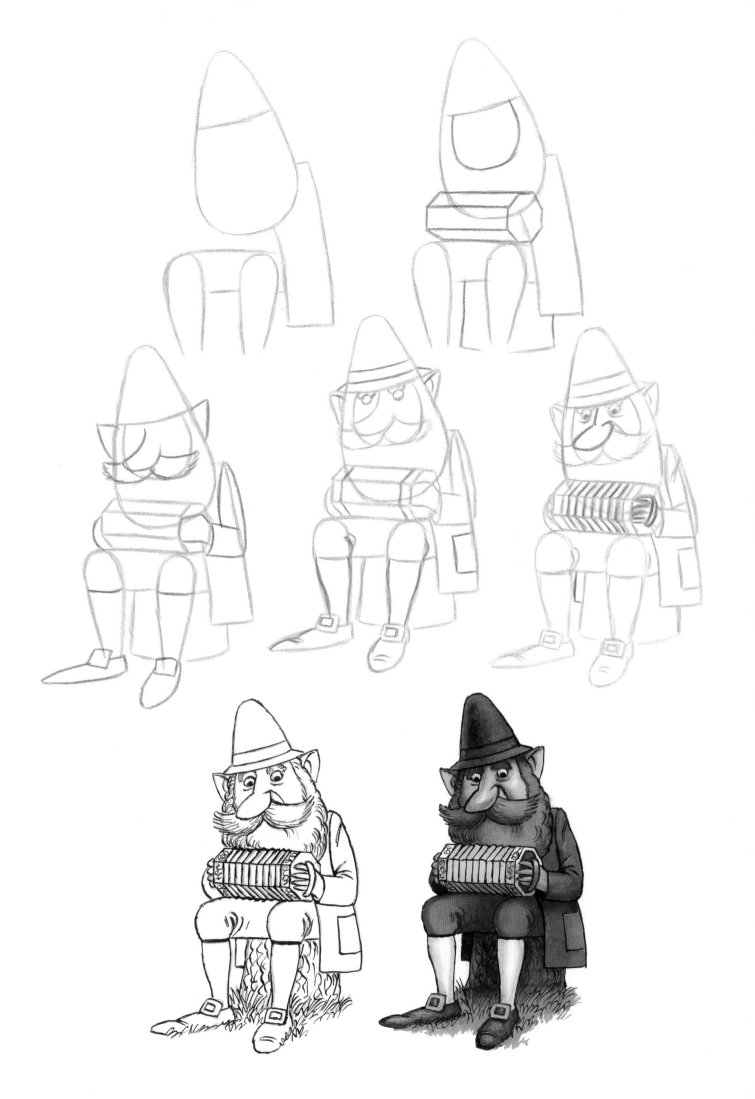

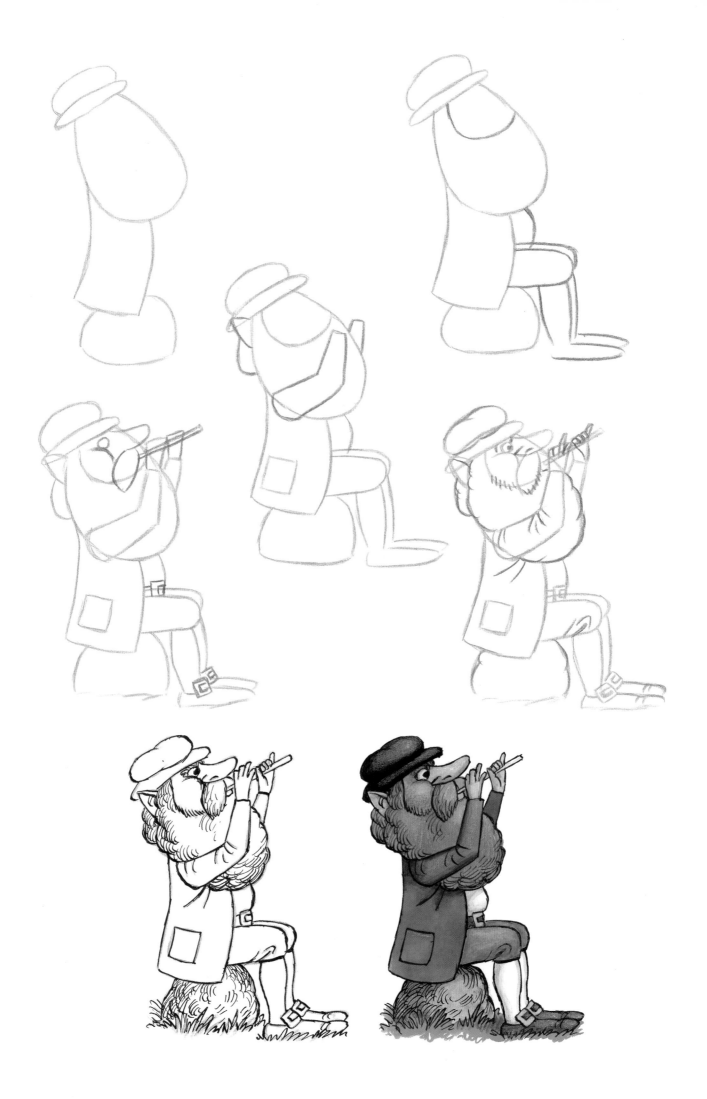

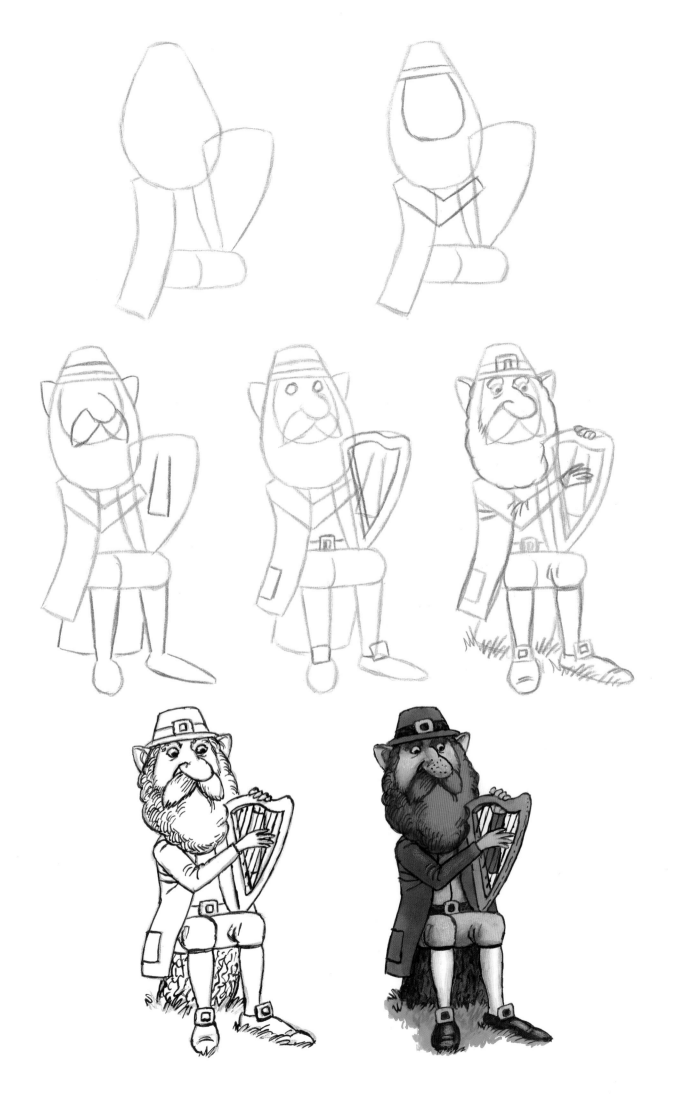

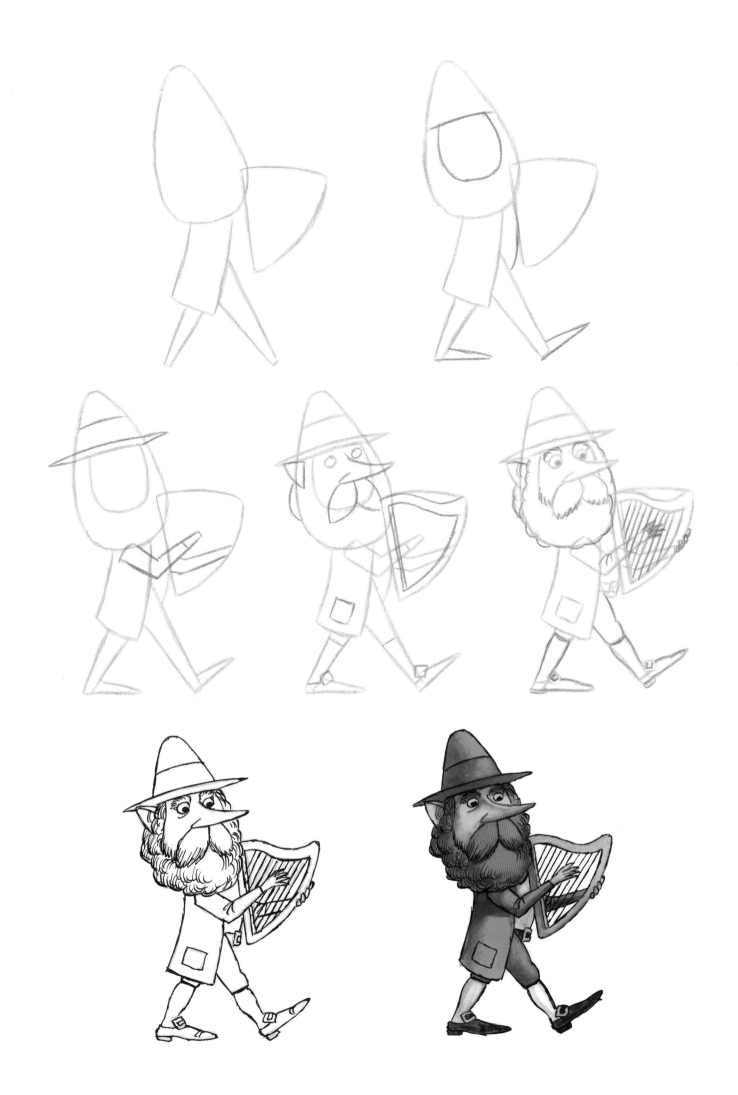

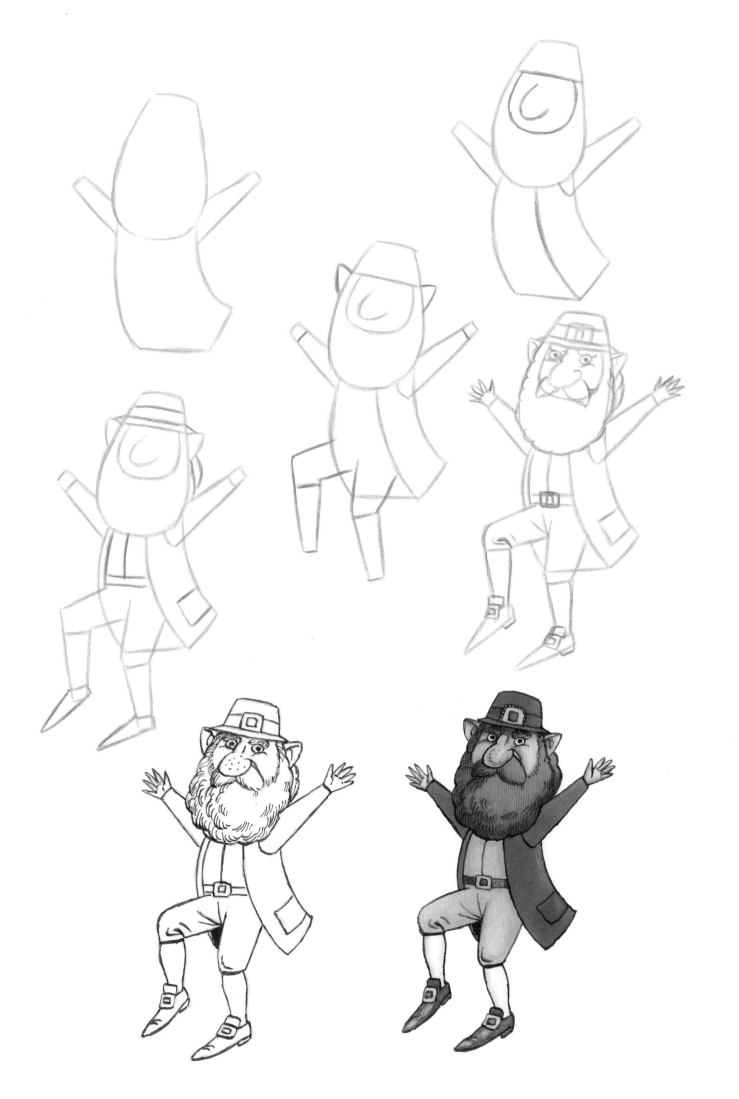

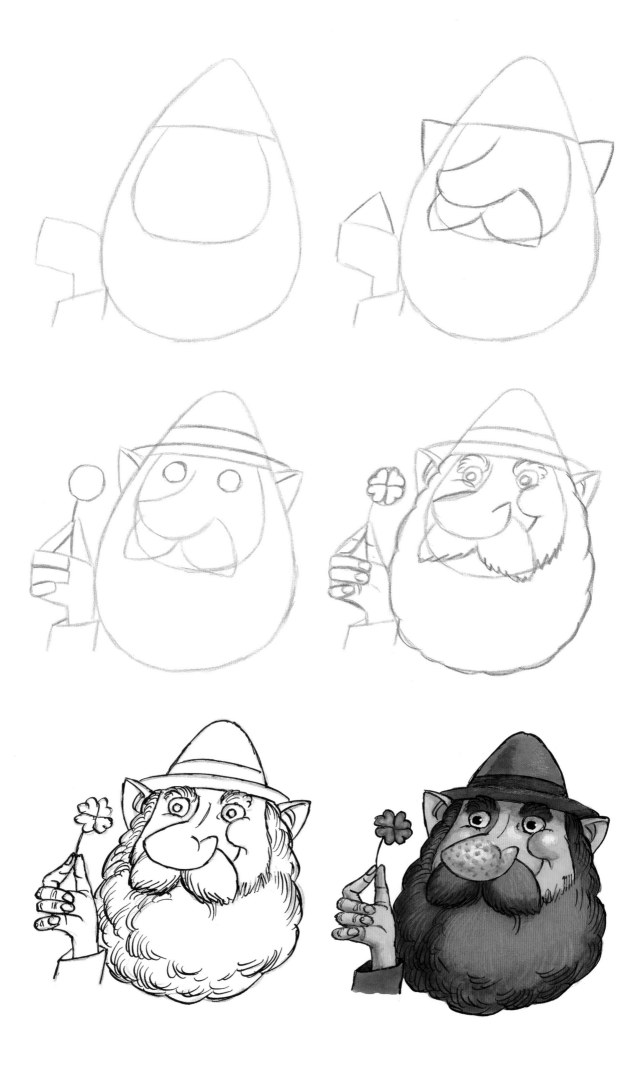

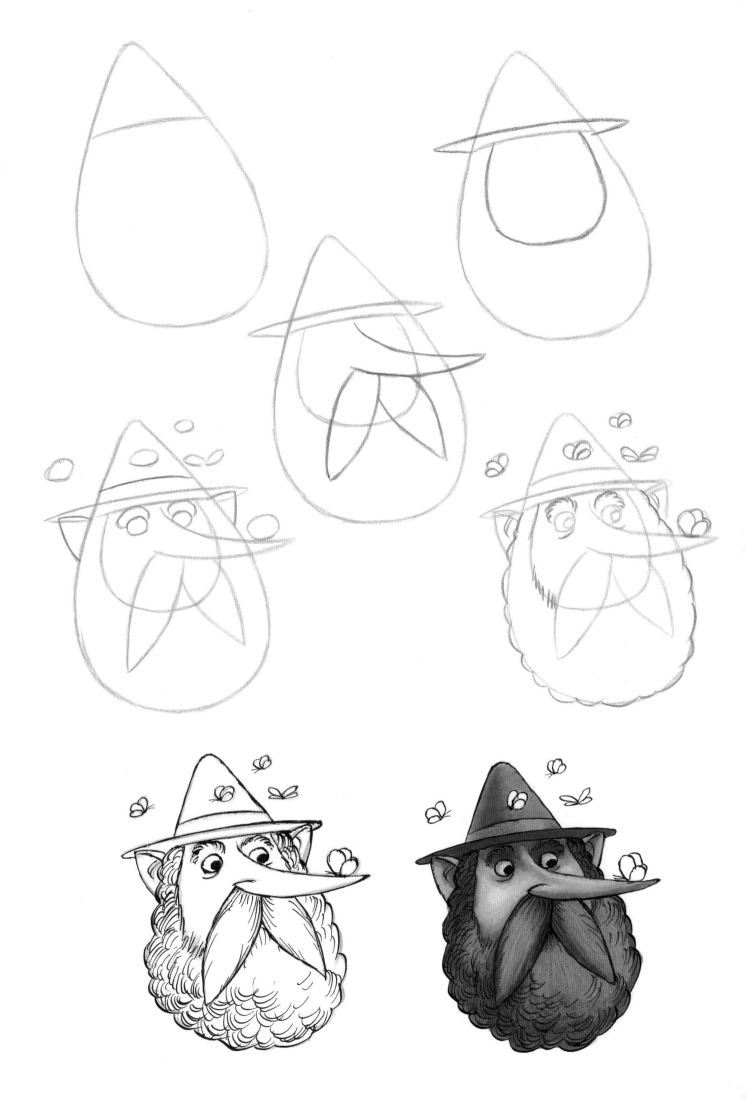

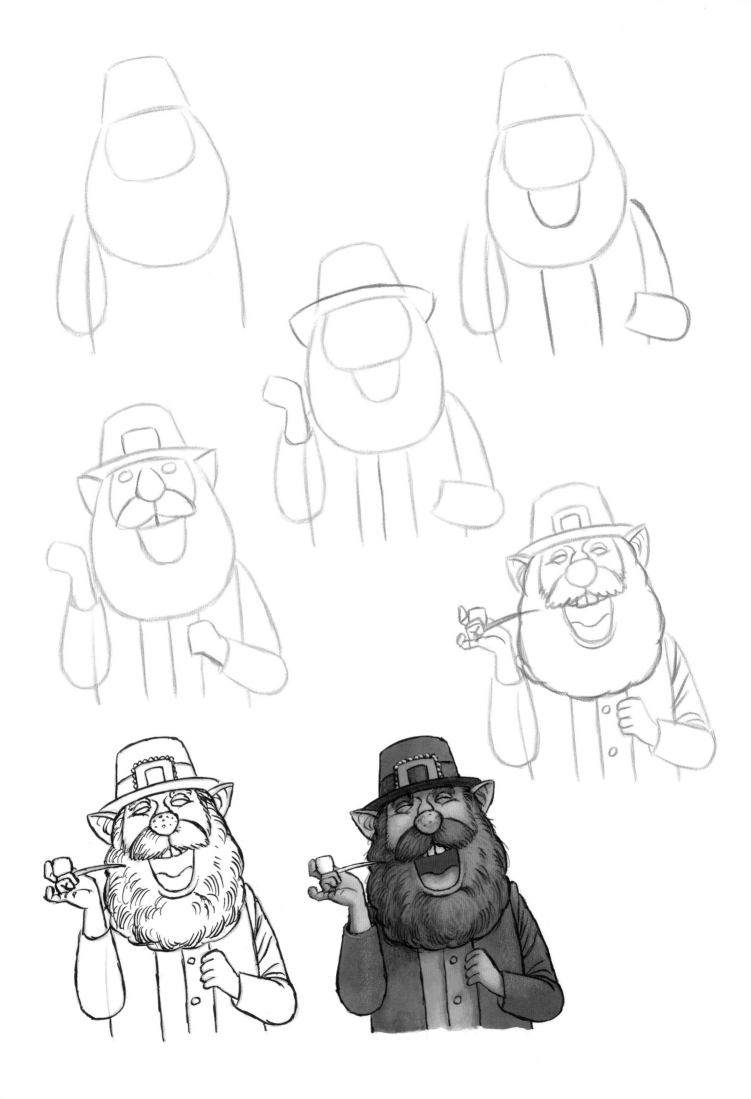

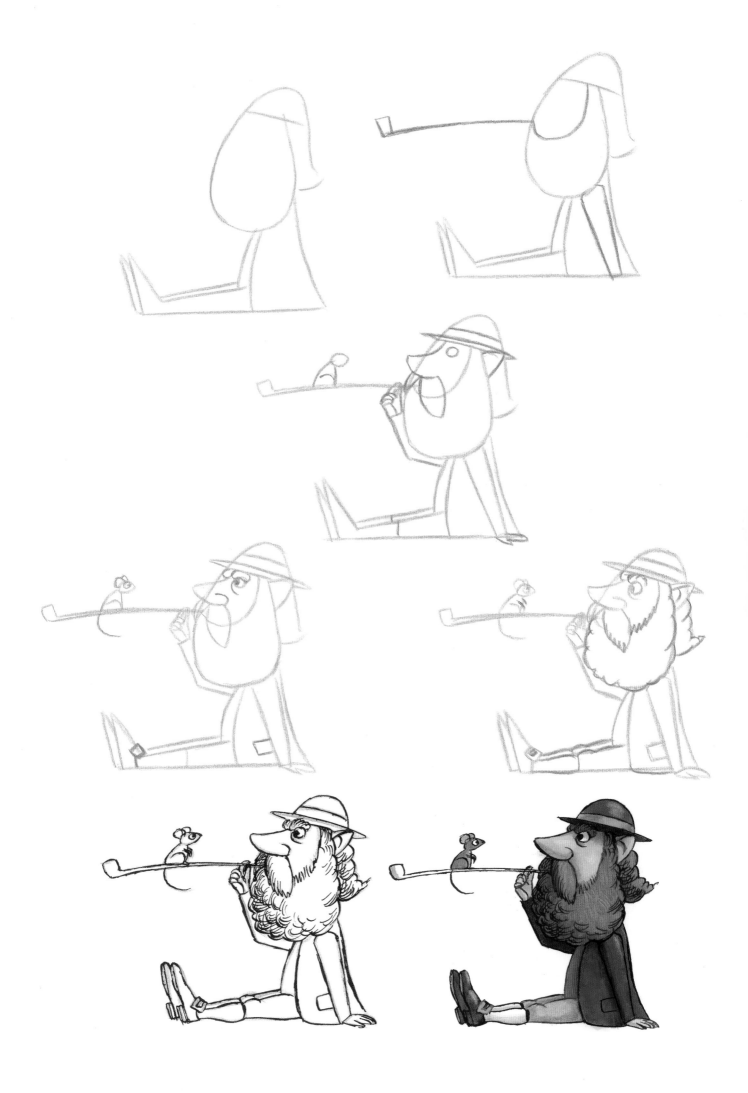

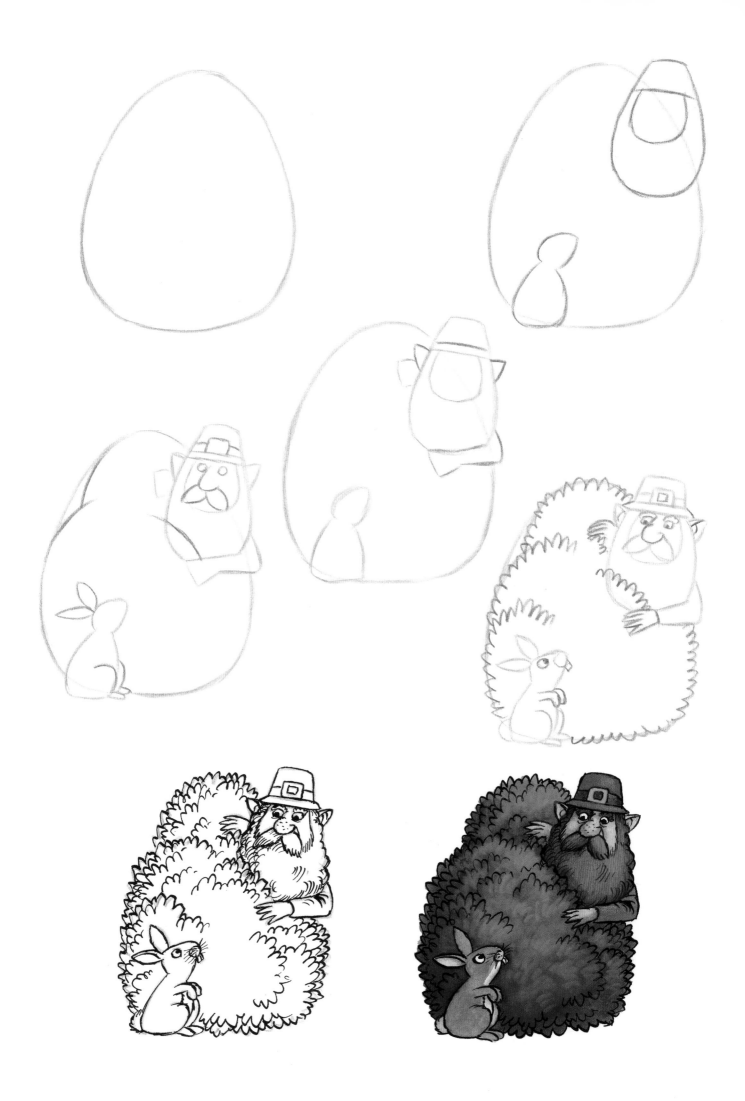

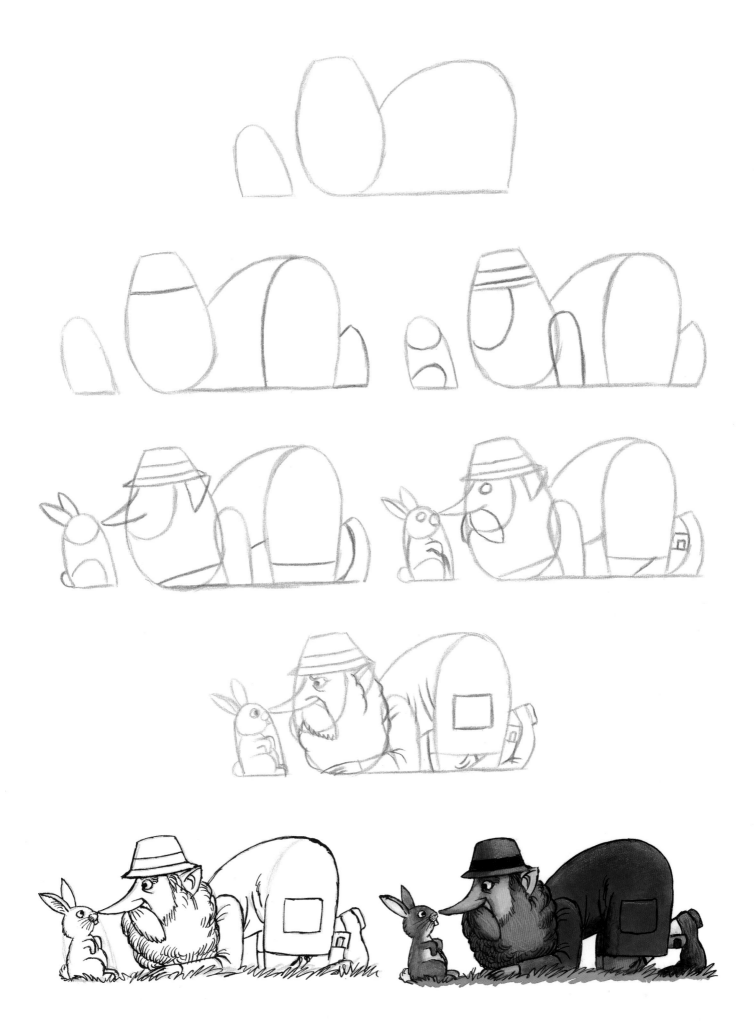

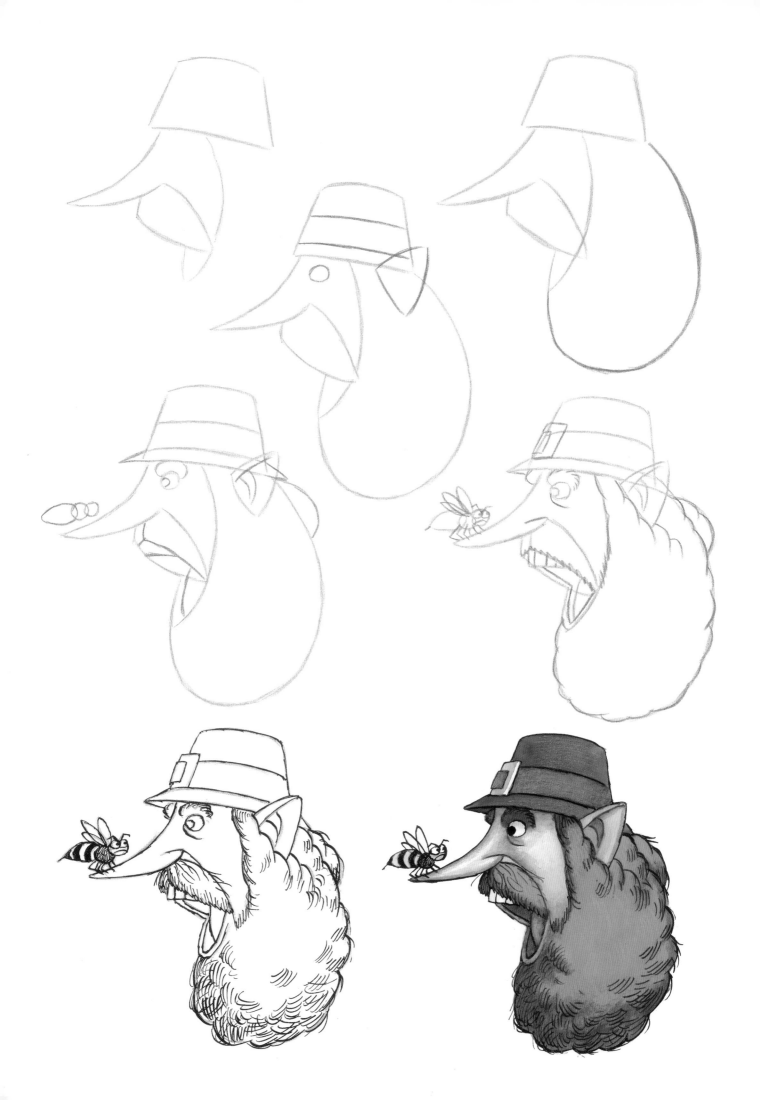

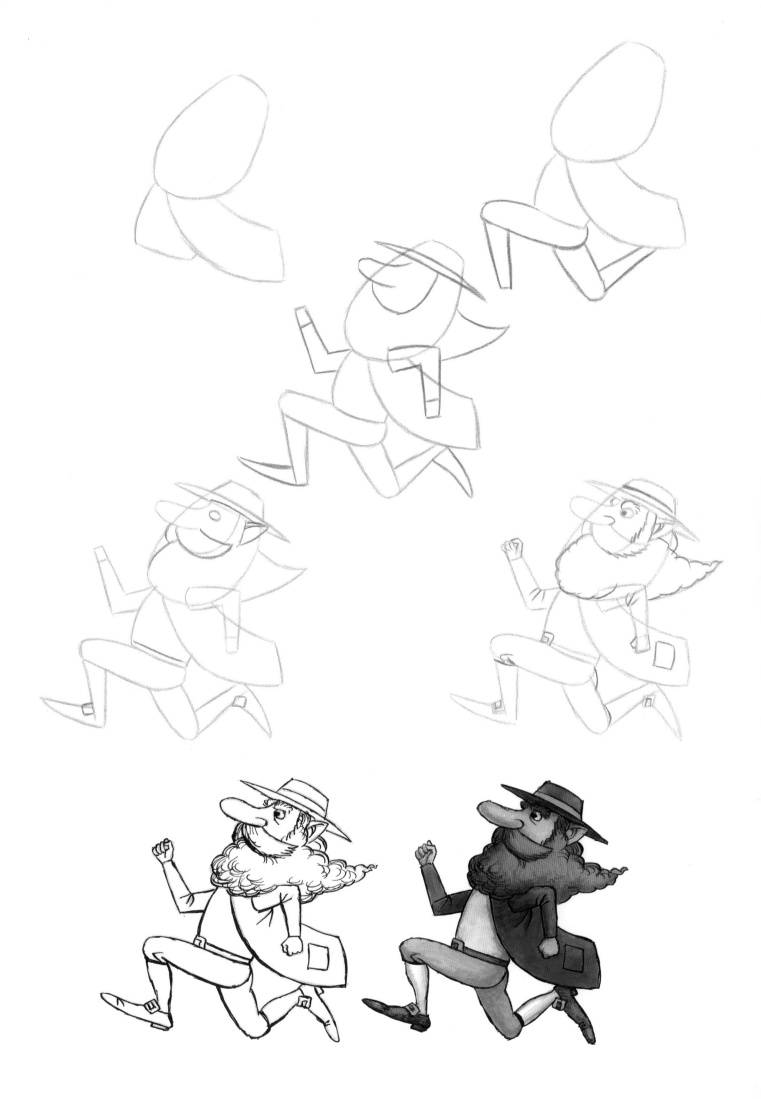

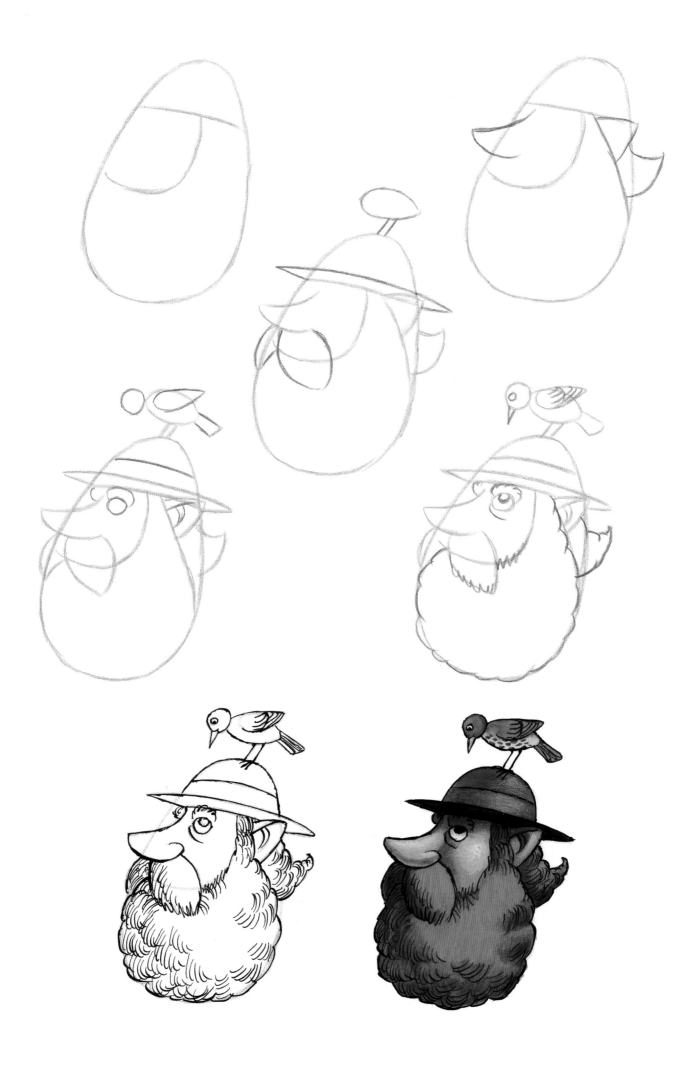

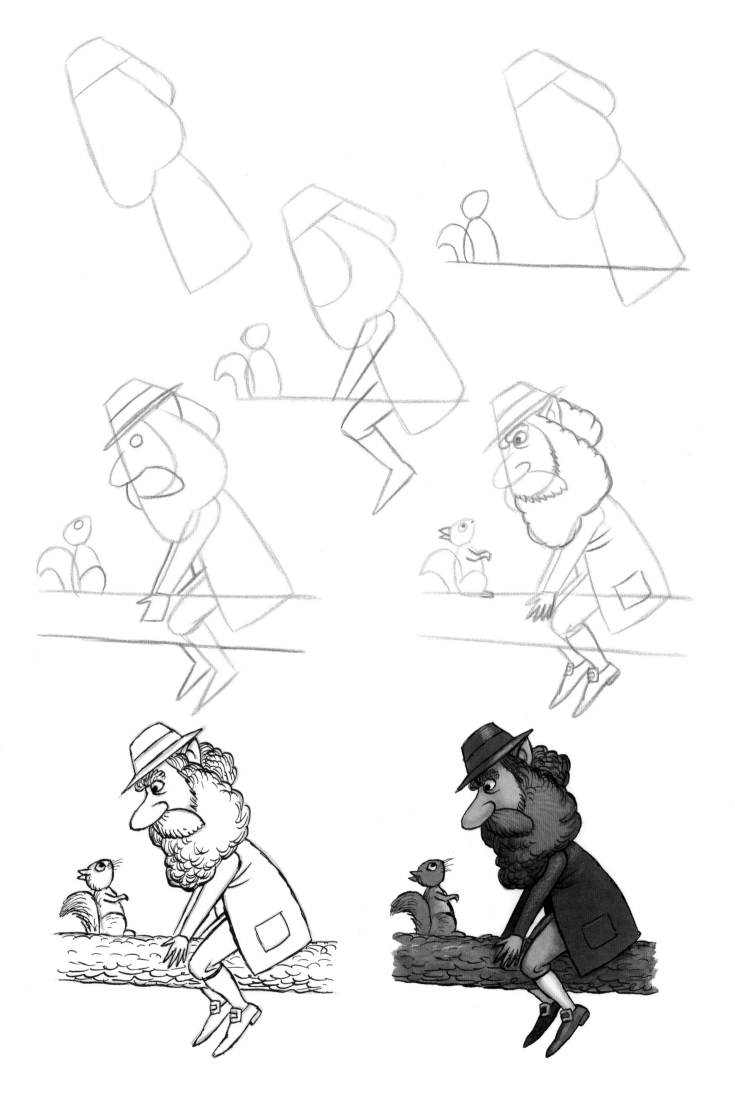

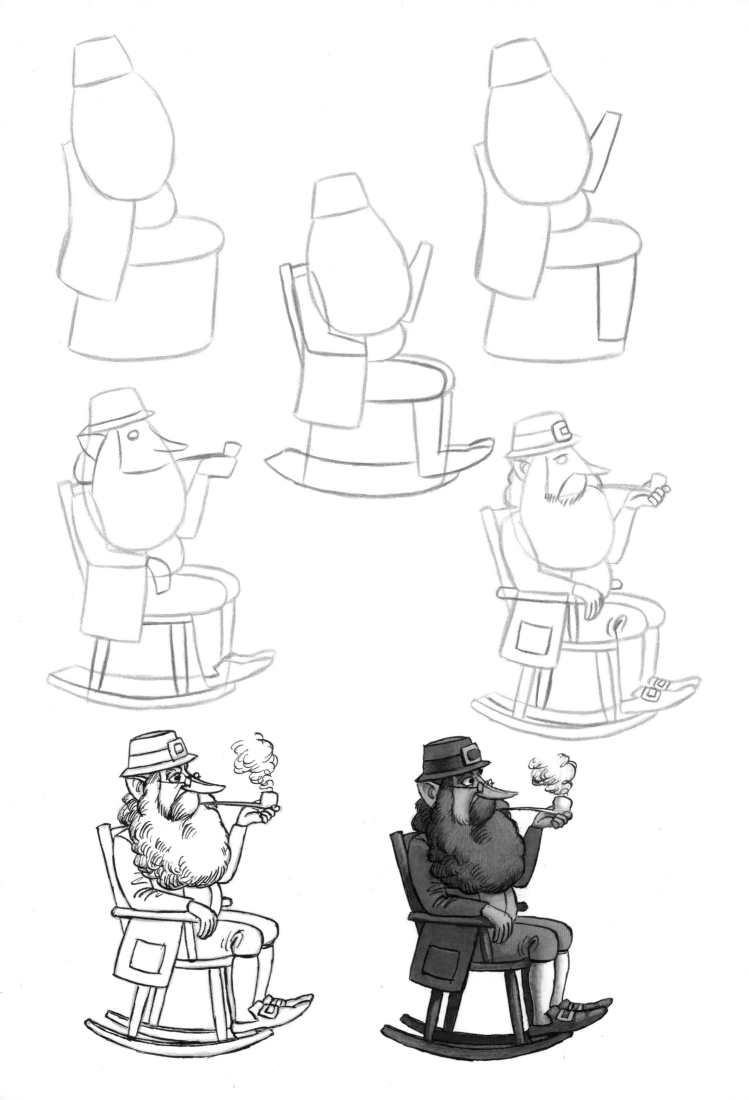